STRAIGHT TO THE HEART
Children of the World

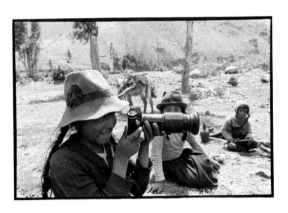

E T H A N H U B B A R D

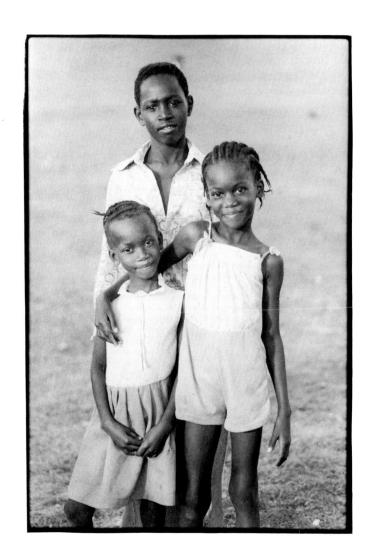

PREFACE

In the spring of 1978, nearing my thirty-eighth year and determined to bring a deeper sense of fulfillment into my life, I sold my house and land in northern Vermont and began spending as much time as possible with rural and indigenous people.

I first traveled in my VW bus to the reservations of native Americans — Navajo, Apache, Papago, Sioux — with my camping gear stashed beneath my bed. In 1980, I began journeying farther afield: to the Outer Hebrides of Scotland, Egypt, Mexico's Sierra Madre, Nepal, Guatemala, India's Ladakh region, Australia, New Zealand, the Hudson Bay, Sri Lanka, Peru, and the Caribbean. I lived as simply and economically as I could, with a knapsack, a tent and sleeping bag, light cooking gear, cameras and film, and small gifts for the people who befriended me along the way.

Each country that I traveled to was alluring in its own way. The mountains and deserts, the high steppes and tundra, the rainforest jungles, the islands and moors awakened in me a deep sense of appreciation and a fuller understanding of my life. The different cultures proved to be empowering teachers, too. Each village, each family reflected new ways of living.

It was the children who became my greatest teachers, who enlivened me with their spontaneity and enthusiasm for life's broad moments: the licking of an ice cream cone, the rubbing of a big toe in the warm earth. It was easy to photograph them. They were so much more in tune with how they felt than how they looked. These portraits — their lives — are a gift returned to them, and to you, the reader.

Ethan Hubbard
Washington, Connecticut

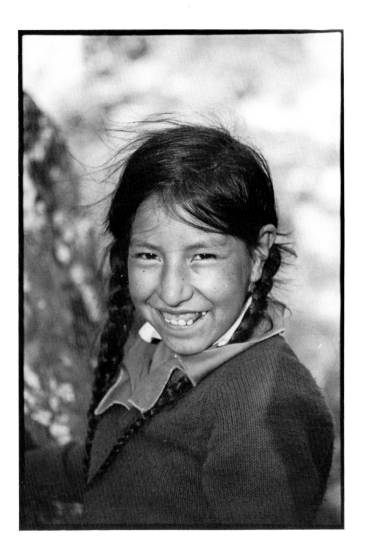

For two winters, I lived in an Indian village in the rainforests of Guatemala. Most of the villagers were Mayans who grew crops of corn and beans and fished from dugout canoes in the blue-green waters of Lake Peten Itza. From the kitchen window of my old thatched cottage, made of mud, skinned poles, and rafters lashed together with vines and grass, I could gaze out and watch the villagers paddling their dugouts down the lake to Flores.

My house and heart were always open to the children in San Jose. They gathered around my home like kids at a movie, awaiting my beckoning gesture. For most of the children, it was their first opportunity to be close to an outsider. On rainy days, ten or twenty little ones spent the day at my house, stringing beads, coloring, or with their heads bent in concentration over a jigsaw puzzle.

* * *

In Scotland, I stayed for four months with an old-fashioned farm family on the island of South Uist in the Outer Hebrides. I lived in their hayloft and shared their

meals of mutton and smoked herring. Often I looked out to a peninsula and a far-distant cottage, and when I asked my family who lived there, they laughed and replied, "It's the old woman who lives in a shoe."

One day I went across the low water channel to the two-room thatched cottage and found seven of the most beautiful, wide-eyed children I had ever seen. They stood, motionless as fawns, and stared at me. Their mother appeared from behind the peat pile.

"I"m Mary MacInnes," she told me, smoothing her rough hands over her apron. "These are the little ones still at home. I had eighteen in all, but most of them have grown and moved away. Now, do come in for tea."

*　　　*　　　*

In 1982 I traveled to the Sierras in northern Mexico to visit the Tarahumara Indians, who lived in caves and stone huts in the high back country. At twelve and thirteen thousand feet above sea level, on tiny plots of stony land, they grew their corn and beans and lived a life far removed from the modern world.

Once by my tent, a crowd of Tarahumara children appeared. I could tell they were intrigued by me, but also shy and afraid. Rummaging for my Polaroid, I snapped a photograph of the group and handed the print to the tallest girl. Others gathered around her to see, and I watched as the smiles spread over their faces.

Then, for nearly an hour, as the sun illuminated their fine features, I made them individual portraits. When they left, each child walked away slowly with a picture clasped close to her chest.

<p style="text-align:center">*　　*　　*</p>

When I traveled for three months through the Himalayas of Nepal, a delightful, easy-going Sherpa guide named Kipa accompanied me, cooking, setting up our camp, and finding an inexhaustible supply of people for us to visit. He spoke no English and I no Nepalese, but he knew intuitively that it was the hermits, the friendly grandmothers and the vagabonds who attracted me.

We usually set up our tent at the edge of a village, and the children came to inspect us in an unceasing stream from morning to night. Kipa and I made many portraits of the children. He was always eager to help, but had apparently never handled a camera, and I was forever imploring him not to chop off the children's head or feet. He would then laugh when I explained this, and it was only when I returned home that their bright faces on the film assured me that he had, indeed, understood.

<p style="text-align:center">*　　*　　*</p>

In Sri Lanka, I lived several months in a rice harvesting village. Each morning villagers in sarongs and saris bathed in the streams along the trails, and oxcarts

moved along the fringe of the valley. A handful of orange-robed monks walked briskly under black umbrellas, and three white temples glistened halfway up the mountain.

Here the children had never seen a white person. Perfectly motionless and silent, they would spy on me as I rested along the trail. One day a boy called out to me, as if reciting his English lesson, "Hello, Mister. I am fine. Where are you? Good-bye. Thank you," and the children laughed. Soon they lost their self-consciousness and circled around me. I showed them how white the skin was under my wrist-band, and they touched the white skin and stared in amazement up at my blue eyes. They reciprocated by giving me rides on bicycles that had no brakes.

* * *

One summer I spent time with the Inuit people in a village on Hudson Bay. They were an extremely spiritual people, joyful and generous in nature. I taught the children how to play jacks — and usually won — and they in turn taught me their game of climbing over the ice of the bay. Even on warm July days, leaping from iceberg to iceberg was scary business. The open patches were blue-green and clear, and far below the surface the ice had a turquoise glow. Little moonfaced sisters and brothers tugged me across the ice, and whenever we broke through, getting soaked to our knees, we shrieked and hooted in surprise. Hearing our glee, the

elders could not contain their own childlike laughter and rushed down from their houses to join in the game.

* * *

In Alice Springs, Australia, I took a room at the local YMCA and rode my bicycle each day to the edge of town and the squalid encampments of the Aborigines that ringed the city. These were grim hardscrabble camps made of cardboard and tin, where members of the Anmatjera or the Warlpiri tribes lived in family bands.

These Aborigines allowed me to sit with them around their campfires at night and under the shade trees during the day, while the old men carved boomerangs or made spearpoints that never would be used. Even in the face of such hardship and squalor, the old men still taught the children the mysterious dot and arrow symbols of dreamtime — the lineage of their ancestors. Day after day I would pedal in with food and cold milk for these neglected people, and ever so slowly a feeling of trust and friendship developed between us.

* * *

I lived at a land trust commune on the north island of New Zealand, where a handful of adults and children from many countries raised organically grown fruit. During the weeks of harvest, whole families trundled down in the warm sunshine with boxes, crates, and ladders to pick the peaches or nectarines, yellowish fijoas,

grapefruit. By the end of the day there were mounds of the ripe juicy fruit. We would gather on the grass, tired, happy, and sticky, and eat to our heart's content. The children were playful and energetic, and the red juice from peaches would run down our chins as we laughed. It was sweet labor, friends working together harvesting a crop they had nurtured throughout the year.

* * *

In Ladakh, in northern India, I traveled for a month in the Himalayas with a Tibetan pony man named Tsetan. We traveled like desert nomads, putting in long hard days between villages. There was a harsh beauty to the trek: in the biting wind that tore at our faces, in the courage and stamina of our little horses, and in the silence as we lay close together in our blankets around the fire at night.

The children we met loved playing jacks, or flying paper kites no bigger than leaves in the cloudless blue skies. I often held their chapped little hands as we went, hands that felt like iron. I always carried tins of Nivea cream and rubbed their faces with it, looking into their eyes and speaking softly to them all the while.

* * *

For six months I lived in the ancient Incan village of Ollantaytambo, not far from Machu Picchu in southern Peru. I trekked daily in the mountains and made a series of portraits of the Quechua-speakers, descendants of the Incas.

At day's end, I visited with the campesinos in the plaza. Sitting beside the old mothers who made small fires to cook street food, I allowed their small children to snuggle into my arms to escape from the cold. Together we would watch the moon reveal the mists hanging on the two spires of Pincullana, Mountain of Flutes. This time of day, when the form became formless, was my favorite time. I felt ageless, colorless, birthless, deathless, countryless, at peace.

* * *

For a month I lived in an oasis in western Egypt. Over five thousand years old, Farafra had a Biblical feeling. The villagers lived in sand houses, drew their water from deep wells, and plowed their gardens with donkeys. I pitched my tent near the date grove, donned the local garb, and learned a little Arabic.

Often I worked with the village boys scything fodder near their gardens. We would pile huge mounds of the fragrant grasses in the back of their donkey carts and ride through the desert in the late afternoon heat. More likely than not, the boys and I sang English songs I had taught them. I soon gave up trying to correct their pronunciation, and so would join in as we jostled through the desert singing our favorite, "A High-ting We Will Go."

* * *

In Antigua, the West Indies, I photographed one family over a five-year period. My father had introduced me to Antigua as a small boy, and my affection for the Antiguans has grown over the years. As a man in my forties I found myself going back time after time, especially to a village called Ebenezer, where Susan Henry and her family lived.

She was a strong, African-looking woman who served as mother and grandmother to twelve children, and, with no husband to help, managed to look after them as if they were her own. I came as often as I could, watching them go off to school in their neat pink uniforms, or pasturing cattle with them in the hills.

Some days we would walk three miles on a hard thorny path through the mountains to a remote beach. The thorns bloodied my hands and legs, and they, walking barefoot, would stop and reach back, taking my hand to guide me through the especially tangled sections. At the beach, I became their guide, overcoming their terror of ghost spirits called "jumbies" in order to teach them how to swim, holding each child in my arms as we stood cradled in the warm blue water.

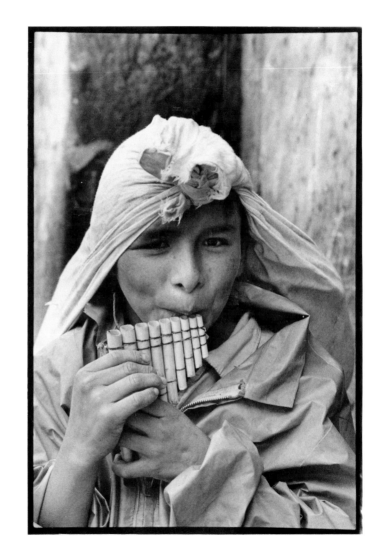

Mountain Musician,
Peru

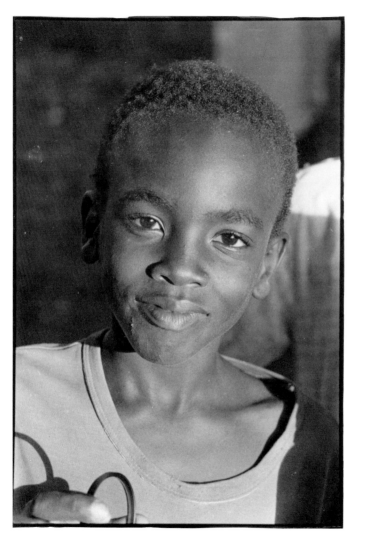

Photographer's Assistant,
Antigua

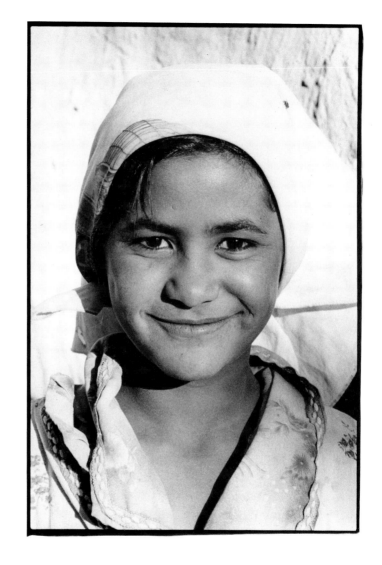

Sabra,
Egypt

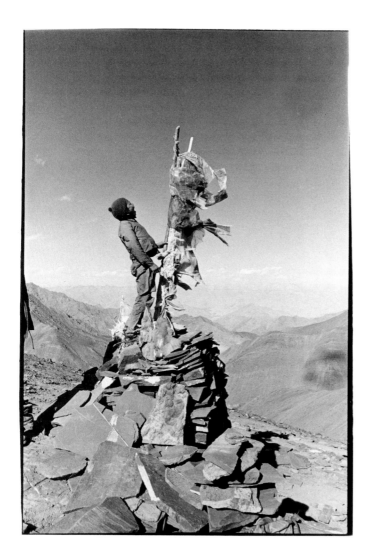

Pilgrimage to Zanskar,
India

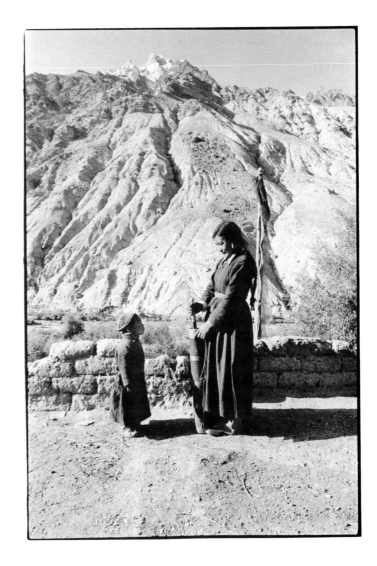

Tibetan Tea Making,
India

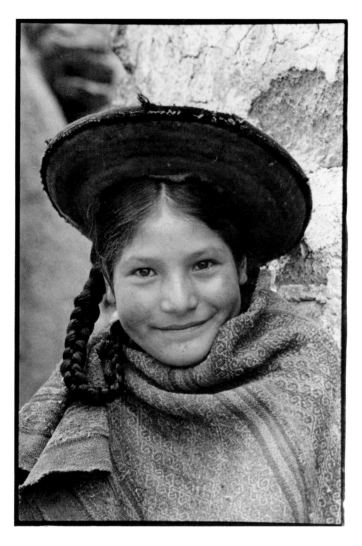

Angelica, Quechua-Speaker,
Peru

Playing Hooky,
New Zealand

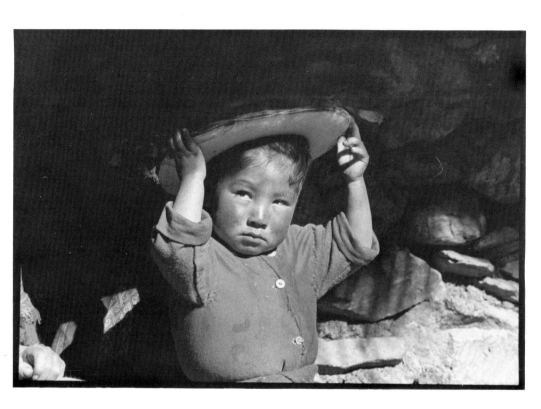

At His Baptism Dinner,
Peru

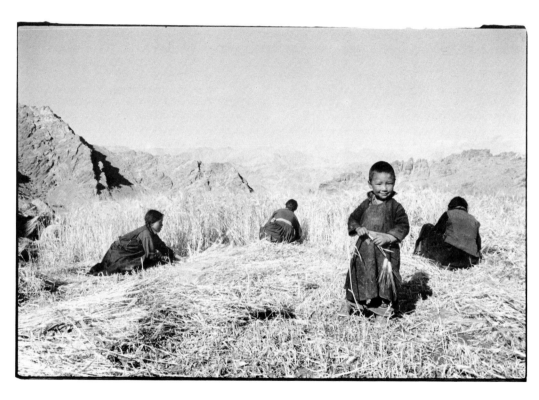

Songs in the Barley Field,
India

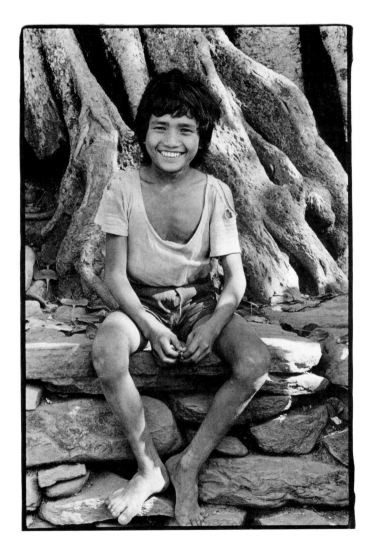

Orphan by Tree,
Nepal

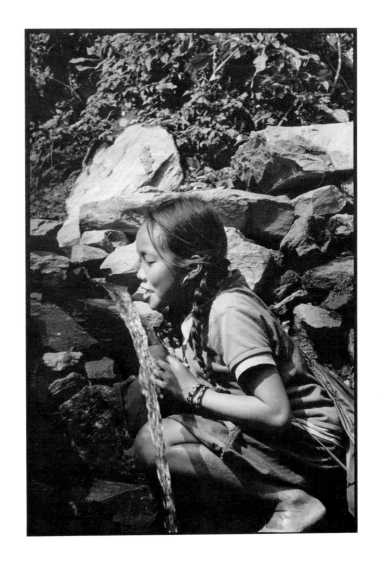

At the Stream,
Nepal

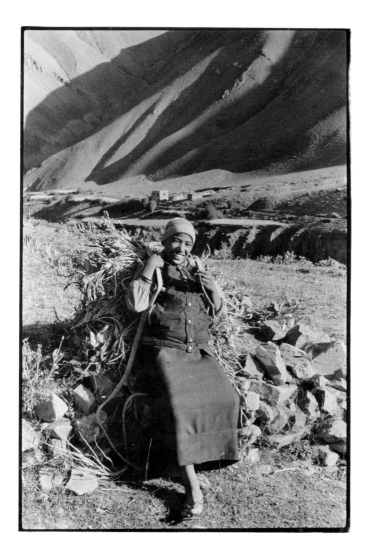

Carrying Fodder,
India

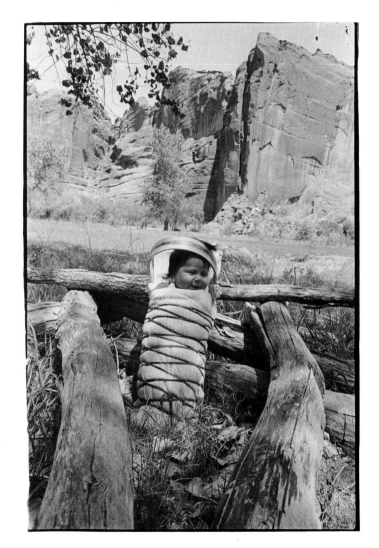

At Grandma's Hogan,
USA

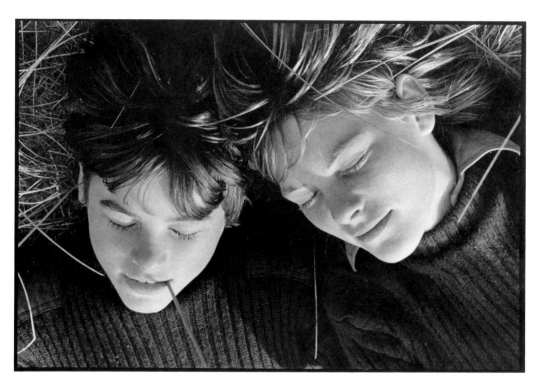

Asleep on the Moor,
Scotland

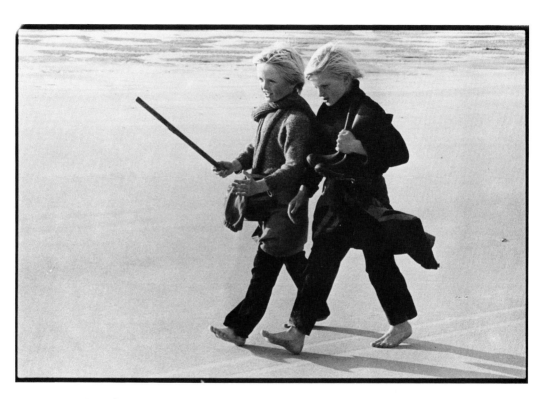

Planning Their Life,
Scotland

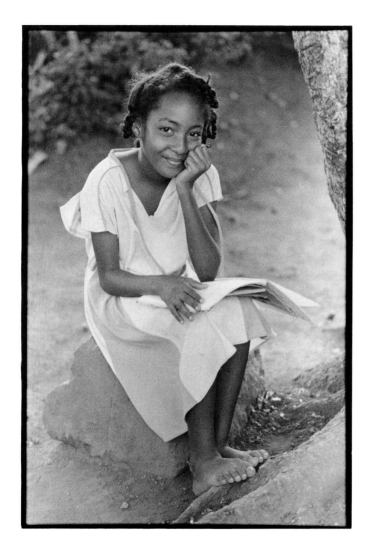

Homework in Back Yard,
Antigua

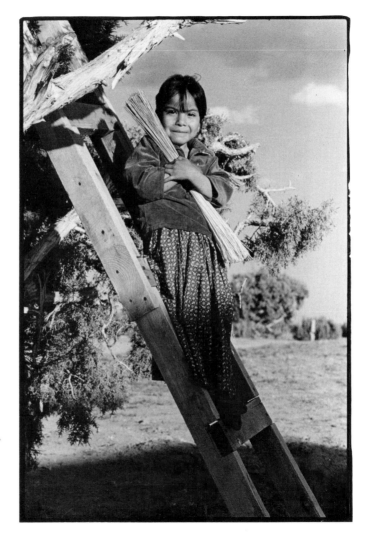

Navajo with Hair Brush,
USA

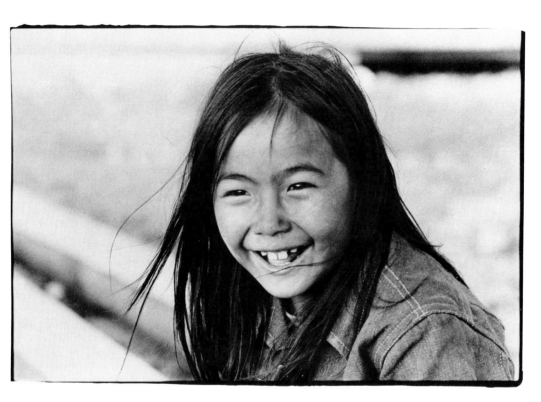

Playing on Icebergs,
Canada

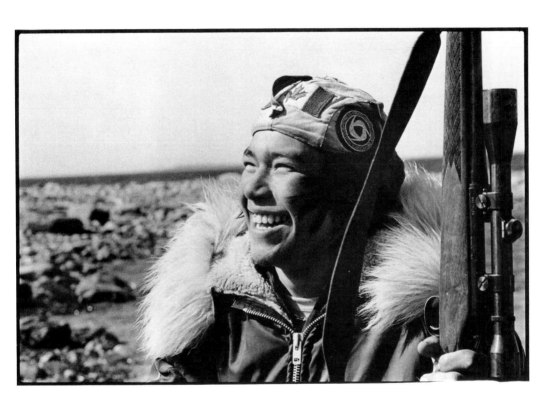

One of Seven Brothers,
Canada

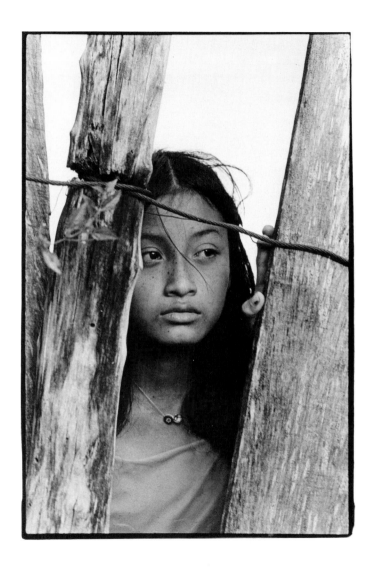

Costura,
Guatemala

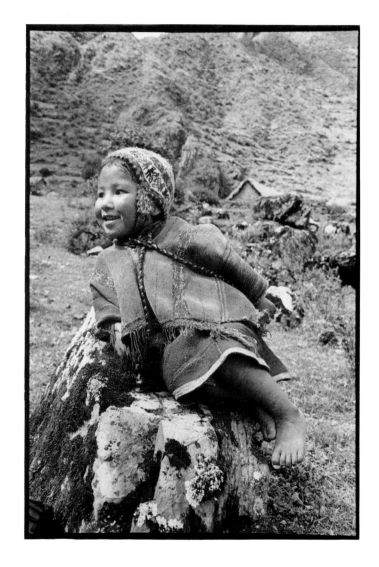

Benigno,
Peru

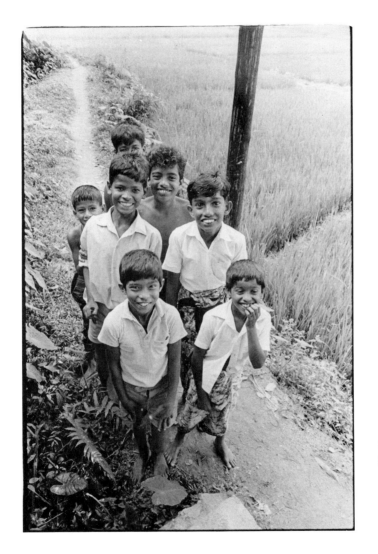

Their First Photograph,
Sri Lanka

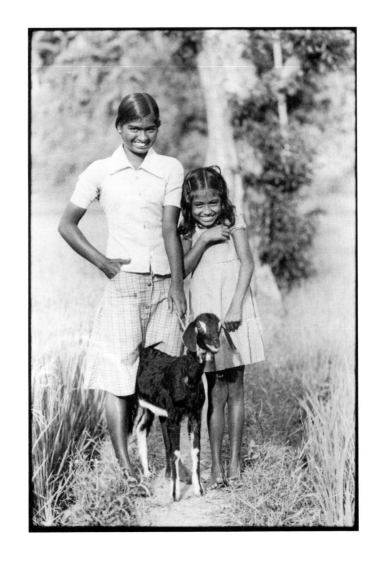

Sisters with Goat,
Sri Lanka

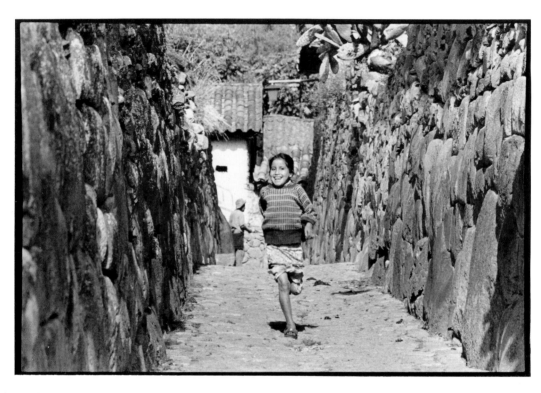

Through Incan Streets,
Peru

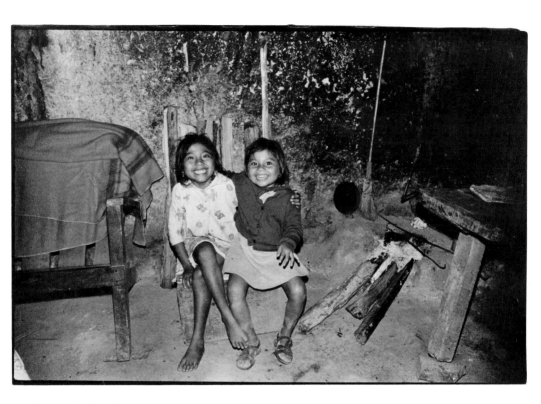

Sisters on the Hearth,
Guatemala

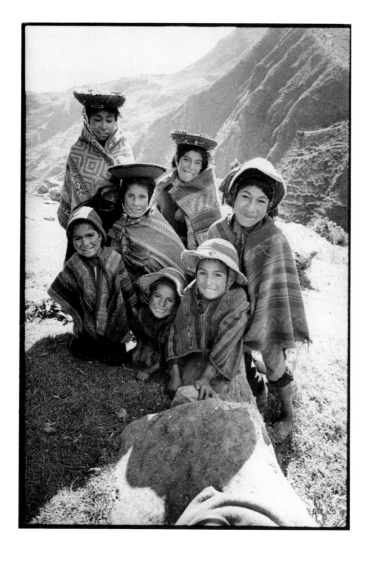

Quechua-Speakers,
Peru

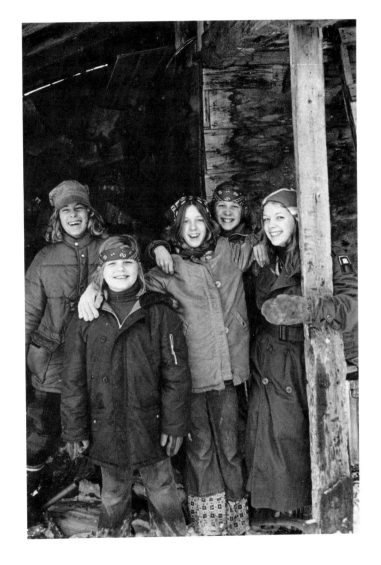

In from Sledding,
USA

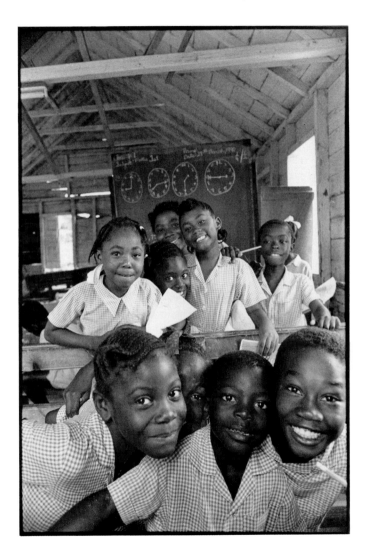

Rural School,
Antigua

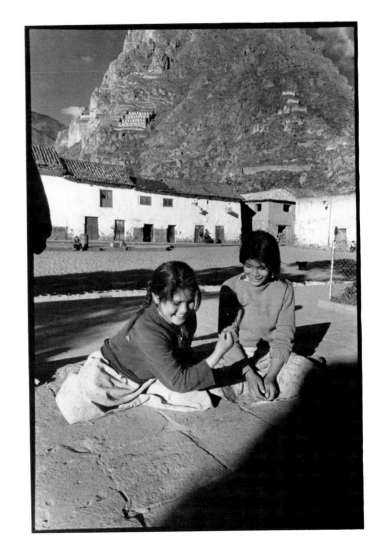

Playing Jacks,
Peru

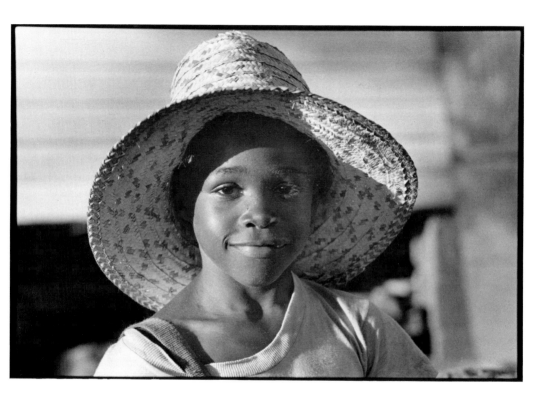

Kenny,
Antigua

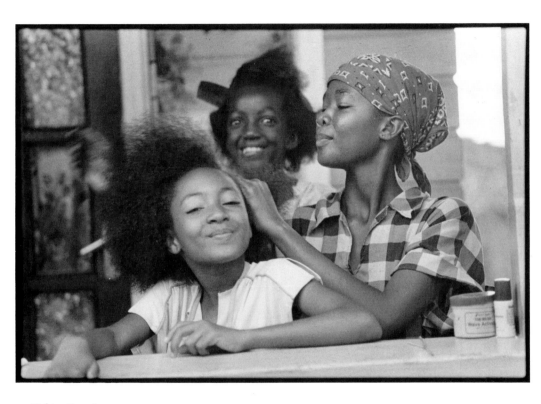

Making Corn Rows,
Antigua

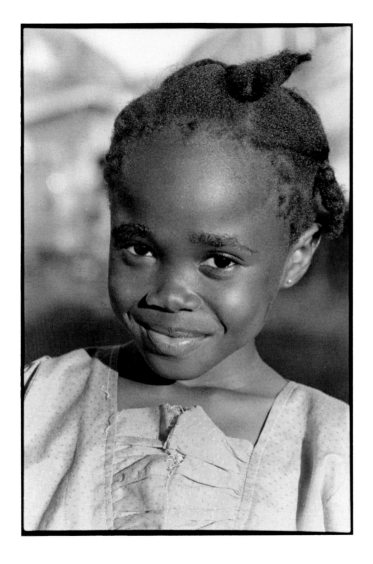

Shika,
Antigua

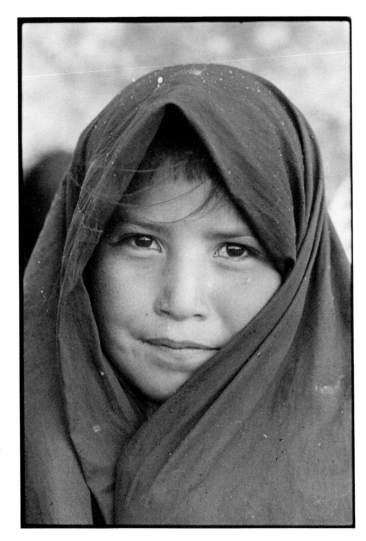

Sheep Herding in Snows,
Mexico

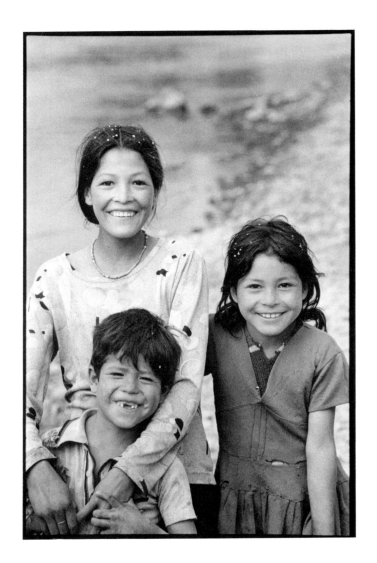

Family Birthday Party,
Peru

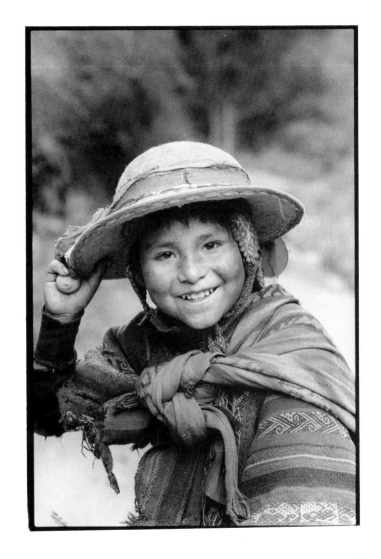

Down to Town,
Peru

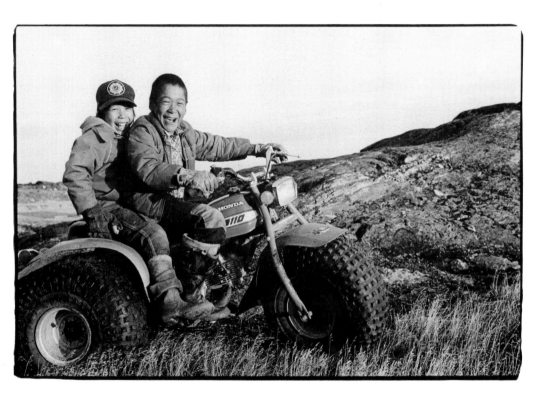

Across the Tundra,
Canada

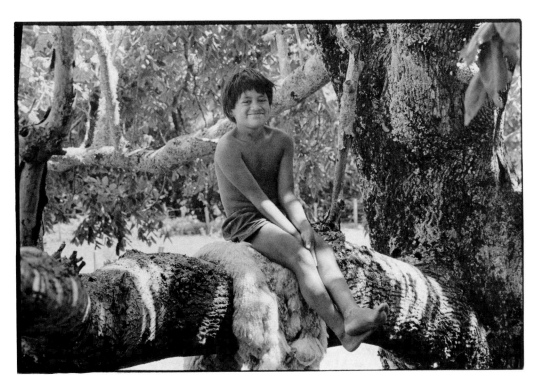

In the Bush,
New Zealand

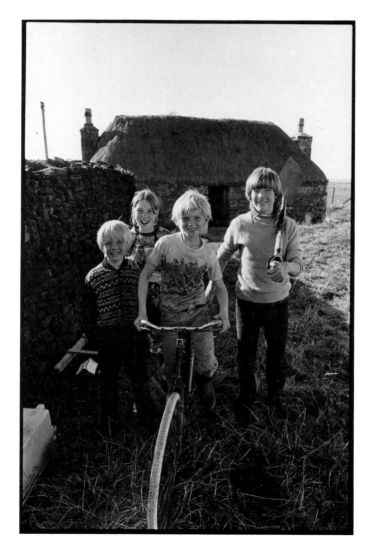

By the Peat Pile,
Scotland

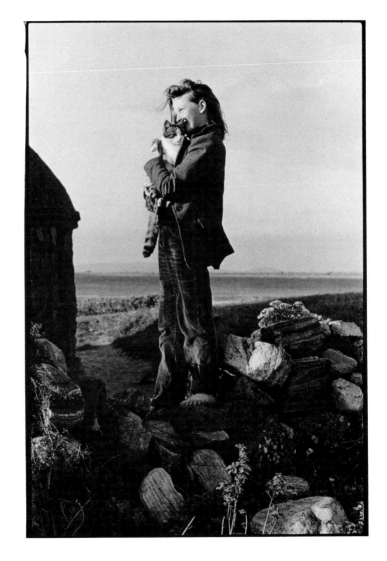

Moragann and Cat,
Scotland

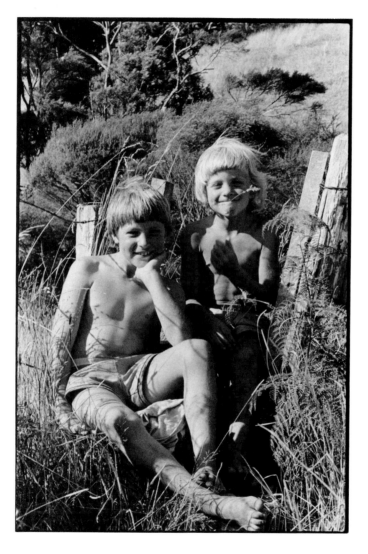

On the Commune,
New Zealand

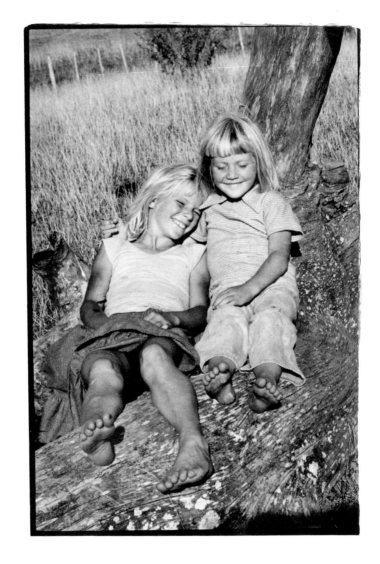

On the Commune,
New Zealand

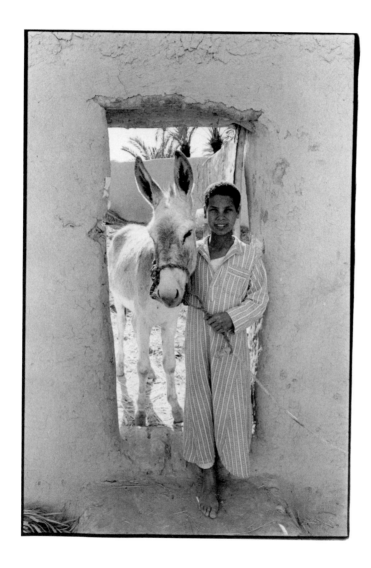

In the Oasis,
Egypt

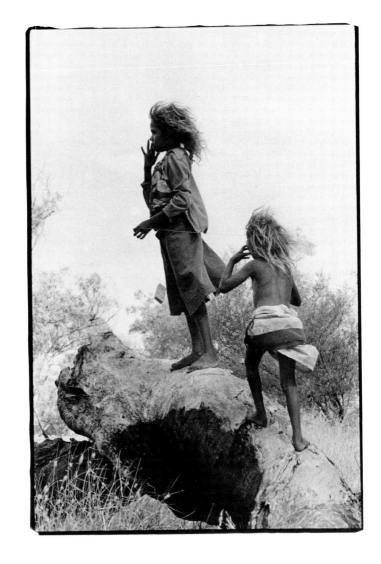

Sisters in the Wind,
Australia

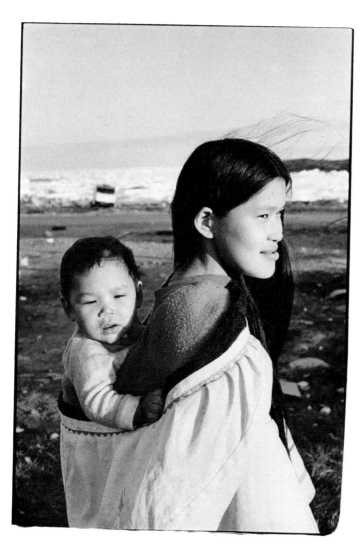

Inuit Brother and Sister,
Canada

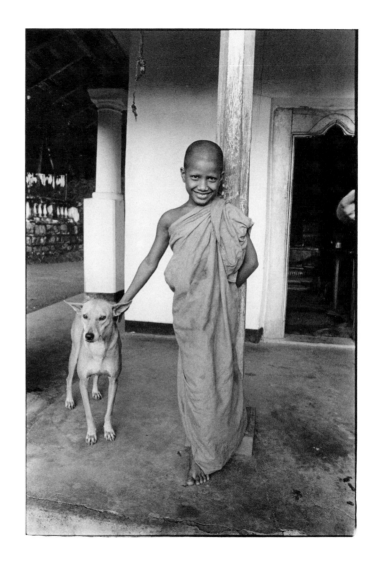

The Little Monk,
Sri Lanka

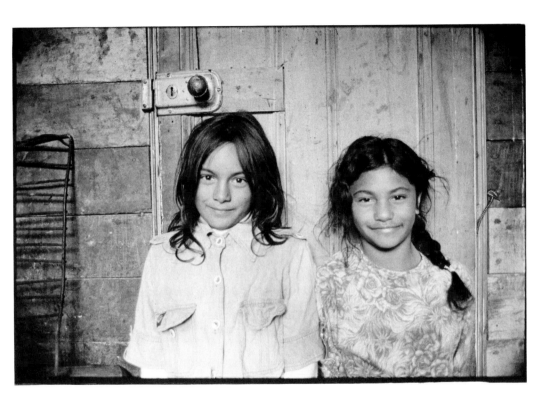

At the Maori Funeral,
New Zealand

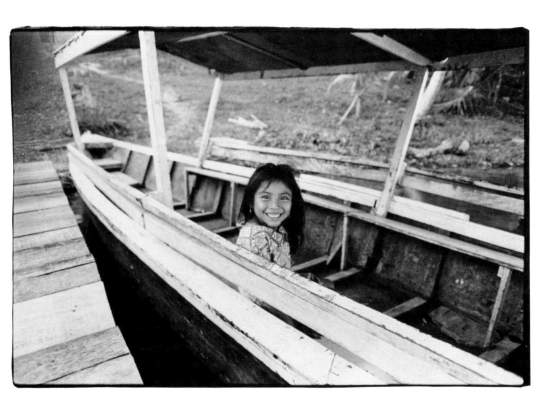

Off to Flores,
Guatemala

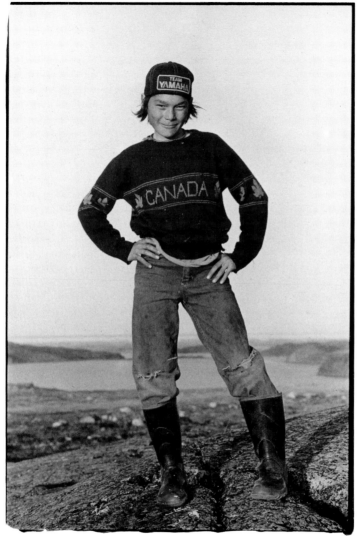

Jim, the Hunter,
Canada

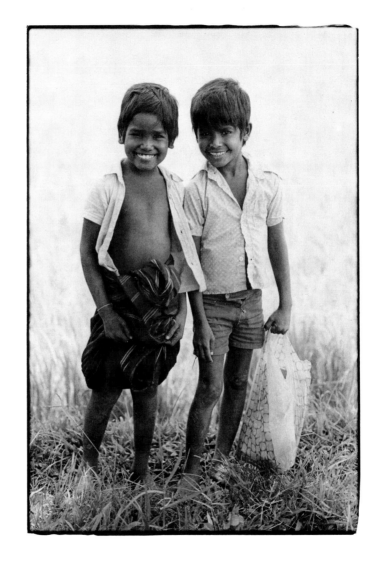

Brothers,
Sri Lanka

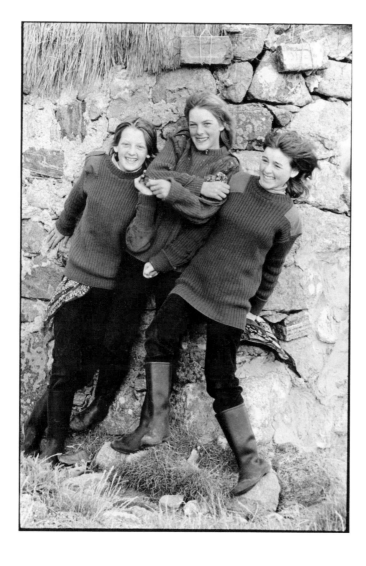

"Dress Alike Day,"
Scotland

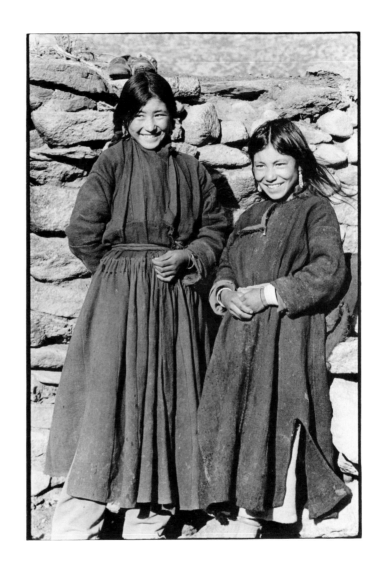

Girls at Sheep Camp,
India

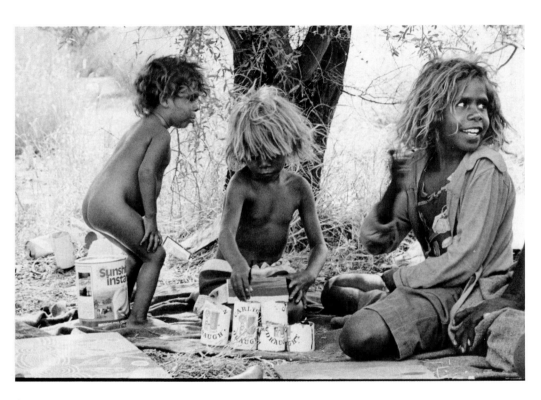

Painting Dreamtime,
Australia

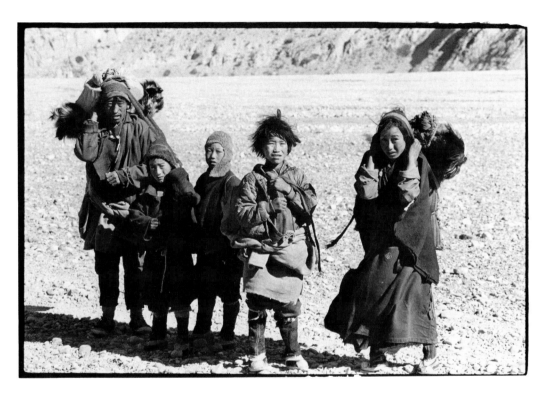

Fourteen Days to Kathmandu,
Nepal

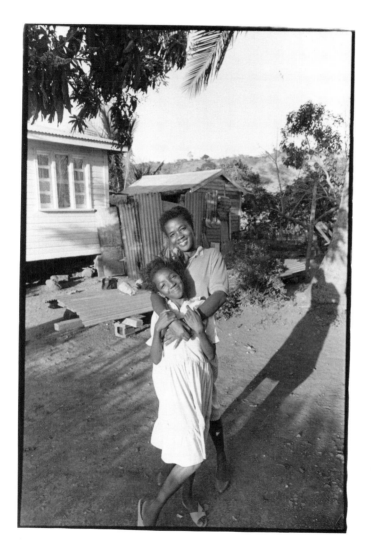

Mother and Daughter,
Antigua

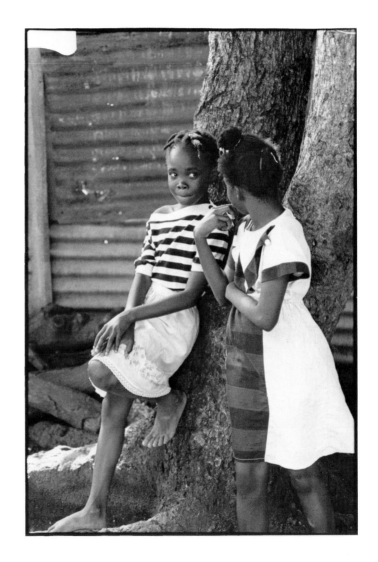

Shika and Latashia,
Antigua

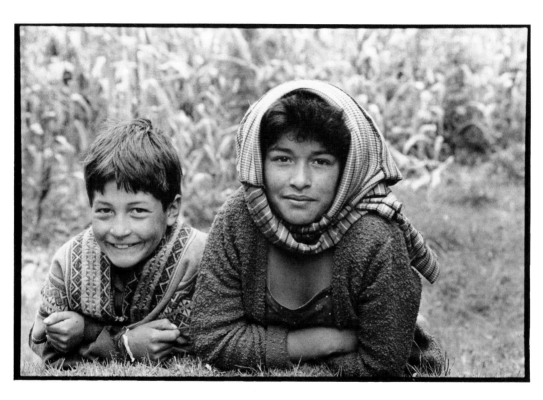

Hernan and Laura,
Peru

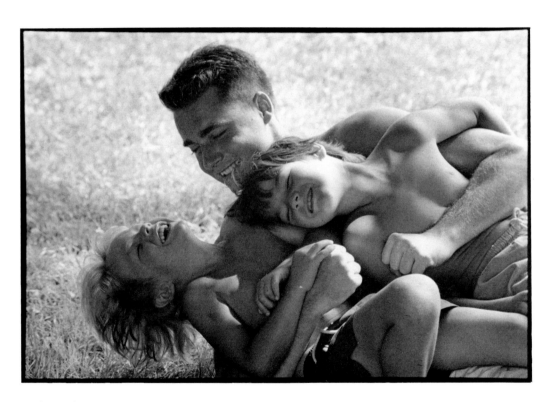

The Tussle,
USA

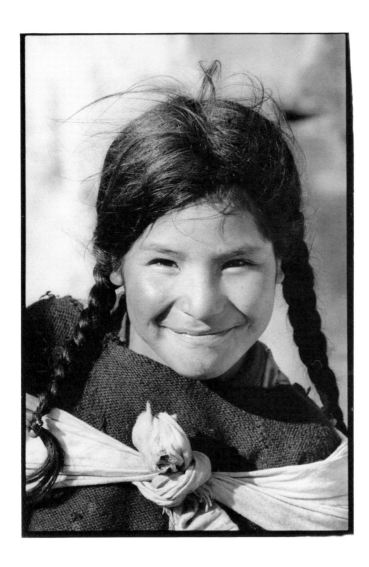

Marselena,
Peru

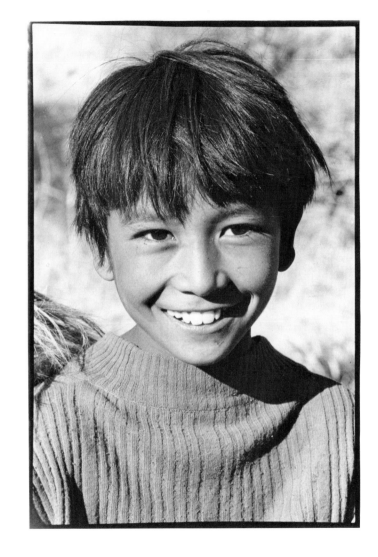

Yak Herder,
Nepal

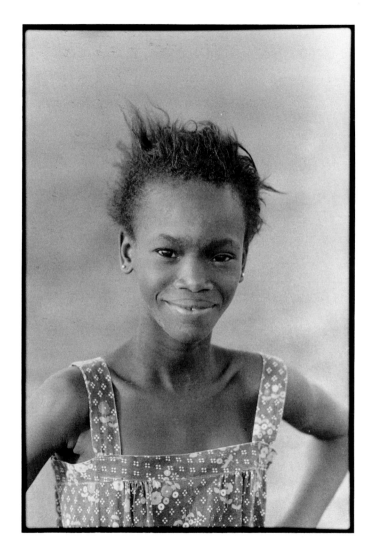

Dona Lee,
Antigua

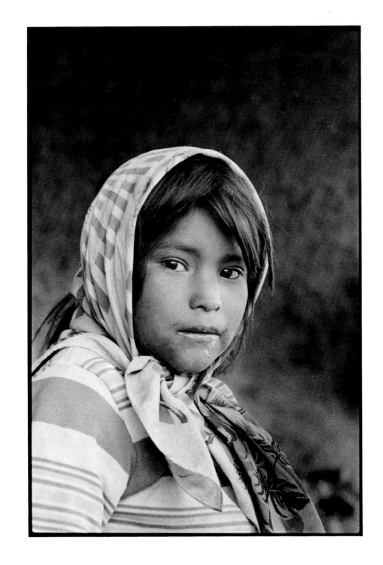

Tarahumara Girl,
Mexico

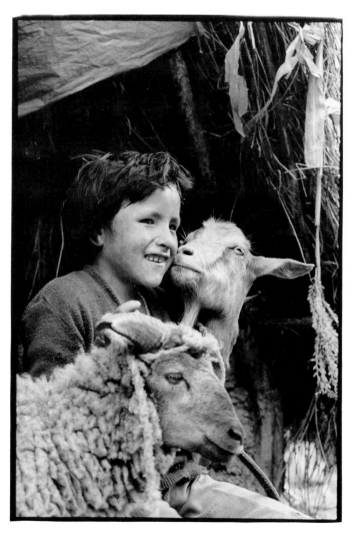

Young Herdsman,
Peru

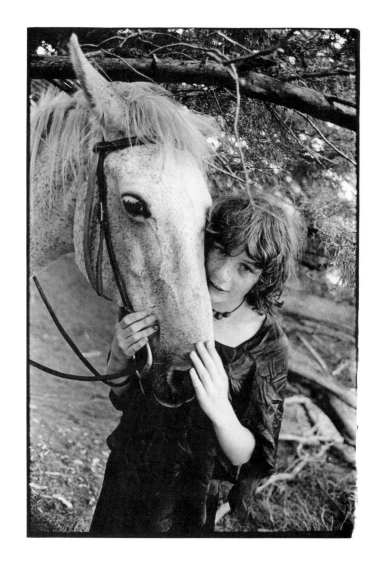

Tanya with Horse,
New Zealand

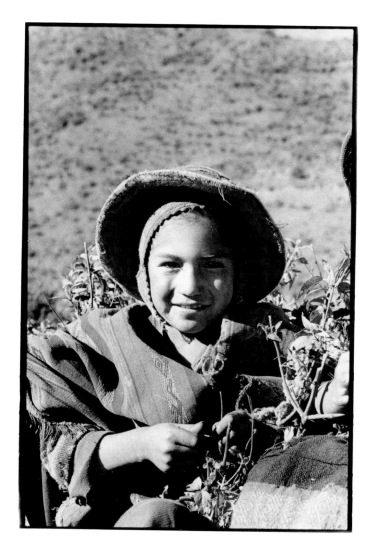

Potato Harvester,
Peru

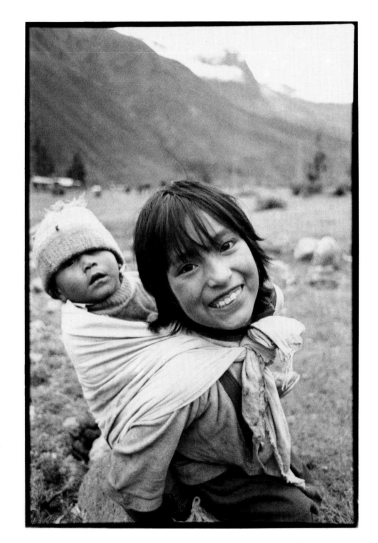

Perpetual Baby-Sitting,
Peru

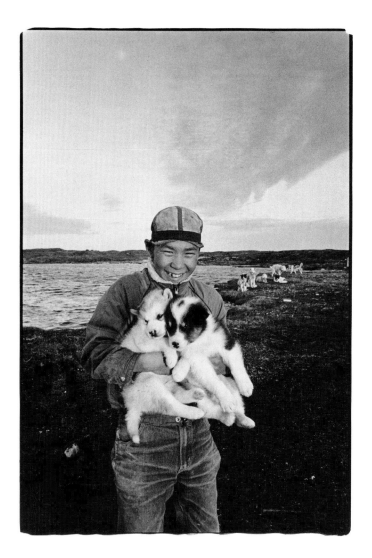

Ricky and His Sled Dogs,
Canada

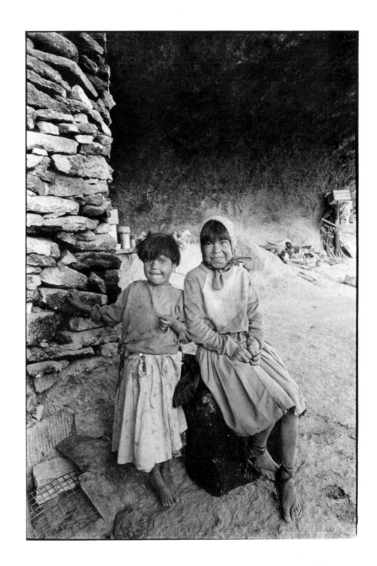

At the Cave,
Mexico

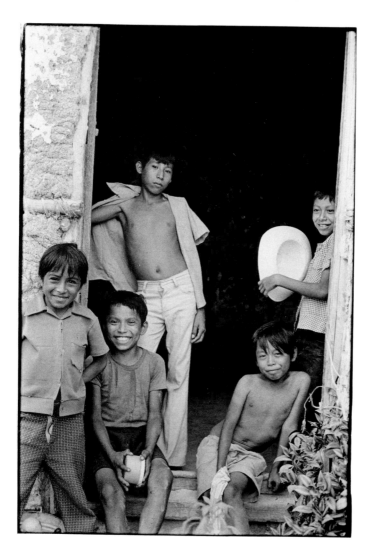

Village Boys,
Guatemala

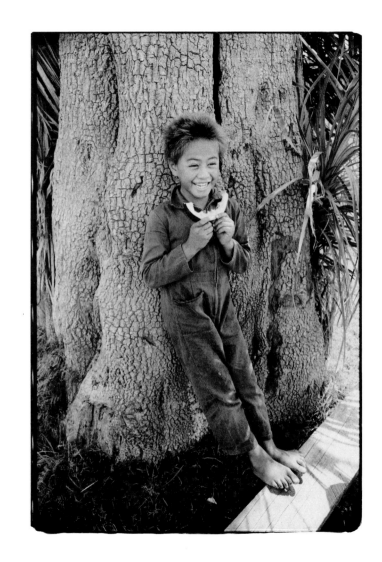

At the Feast,
New Zealand

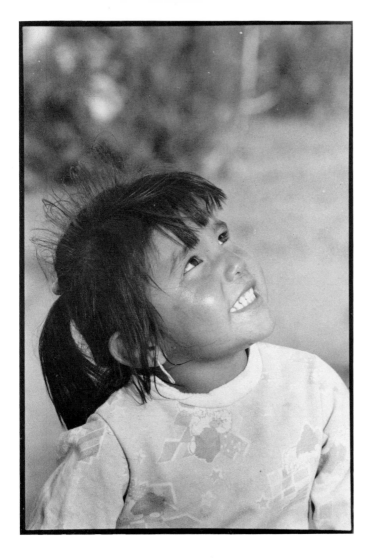

Upon Seeing the Rainbow,
USA

Chelsea, Vermont 05038.

This book has been reproduced in the
United States of America. It is designed by
Todd Smith of Penacook, New Hampshire,
published by Craftsbury Common Books of
Chelsea, Vermont, and printed at Northlight
Studio Press of Barre, Vermont, 1992.

STRAIGHT TO THE HEART is distributed by
Chelsea Green Publishing Company
205 Gates-Briggs Building, P.O. Box 428
White River Junction, VT 05001
802/295-6300 FAX: 802/295-6444

Hubbard, Ethan, 1941-
Straight to the heart : children of the world
by Ethan Hubbard
 p. cm.
ISBN 0-9604992-1-0 (pbk.): $10.95
1. Children -- Portraits. I. Title.
TR681.C5H83 1992
779' .25' 092 -- dc20
 92-4144
 CIP

779.2509 Hubbard, Ethan,
HUB 1941-

14000 Straight to the
 heart.

$10.95

DATE